PETER THORPE

BARK!

THE

HERALD ANGELS

SING

THE DOGS
OF
CHRISTMAS

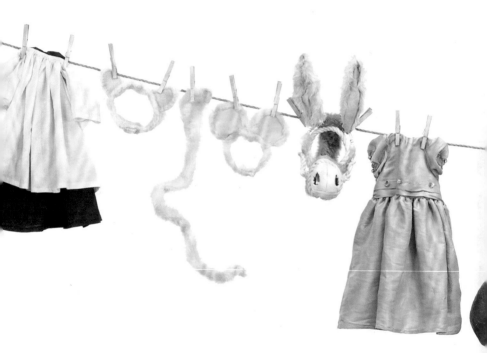

 The Countryman Press
A division of W. W. Norton & Company
Independent Publishers Since 1923

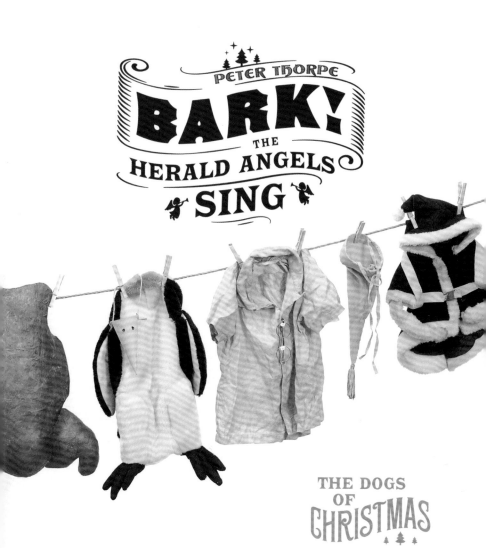

PETER THORPE

BARK!
THE
HERALD ANGELS
SING

THE DOGS
OF
CHRISTMAS

Book design by Nick Caruso Design
Manufacturing by RR Donnelley, Shenzhen

The Countryman Press
www.countrymanpress.com

A division of W. W. Norton & Company, Inc.
500 Fifth Avenue, New York, NY 10110
www.wwnorton.com

978-1-58157-416-6 (hc.)

10 9 8 7 6 5 4 3 2 1

DEDICATION

With special thanks to Paddy, Raggle, Julie, Joe, Cal, and Toby
for their patience and participation each Christmas.
Also to the friends, family and clients whose encouragement
has inspired me to make this series.

CONTENTS

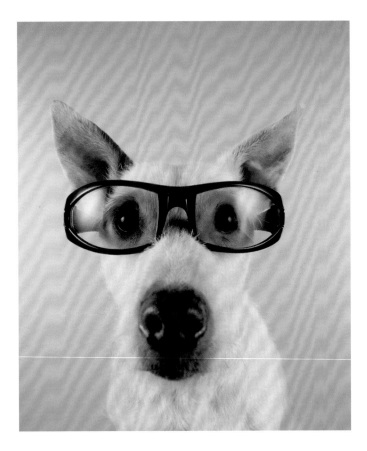

early 30 years ago, we fostered a terrier mix named Paddy. He was quite a character. His behavior was certainly challenging—he greeted people with a wagging tail and a look of interest that would quickly turn into a snarl if they attempted to stroke him—but we loved him, and soon enough, he became our full-time adopted pet. Rather than leave him home, I would bring Paddy to the photography studio each day. He would usually choose a spot to sit close to the action, near the camera where the lights and all the attention were focused. Occasionally he made his way into a test shot or two. This was how I discovered that Paddy was a terrific model . . . which was sort of surprising, based on his cranky demeanor.

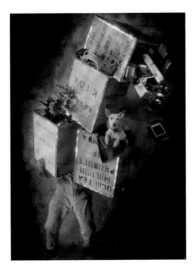

When I moved to a new studio, as a promotional piece, I sent out cards with a staged photograph of

me appearing to hold stacks of packing cases, set up in positions as if about to tumble over. I placed Paddy in one of these boxes, his paws draped over the side, ears pricked up looking sweet and attentive—again, he proved to be a perfect, calm, and relaxed model.

My moving card photo a success, I transitioned to Christmas cards. I started with something straightforward—Paddy resembled Nipper, the famous phonograph-listening dog from the 1898 painting *His Master's Voice.* (That painting eventually became the trademark for the Victor and HMV record labels.) I set Paddy up in a similar shot and added a red border for the holiday card.

Paddy continued to feature—or else had cameo roles—in a number of further shots . . .

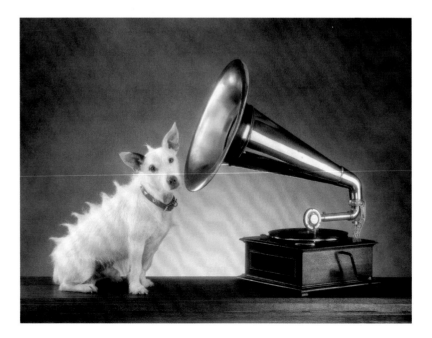

These photos with Paddy turned out to be popular, so I began to shoot a new one each Christmas.

Regarding Christmas themes, there is so much material on which to draw for inspiration, but the pressure is always on each year to come up with original, practical, and affordable concepts. When the winter months would approach, I'd brainstorm with family and friends for new ideas. These were the pre-Internet days, mind you, before people had Pinterest boards and every resource available at the touch of a key. Instead, Post-It notes would bookmark the many pages to photocopy at the library.

In the early years before Photoshop, and even once it had become the standard editing software, I continued to enjoy the process of mak-

ing all my own sets and props by hand. Later I would be encouraged to document this process, as it seemed to be as fun and popular to the viewer as the image itself.

I wanted every card to be original, and I referenced literary and art influences as well as more traditional Christmas imagery. As a youngster, I loved cartoons and comics, and I based each photograph on this simple visual medium. The cards are always intended to work without the need for text. Whatever the theme, when sketching and planning out my early ideas, it is consistently based on the dog being completely comfortable in their natural sitting or standing position. However elaborate and silly the set or costume may be, all the other elements in the shot just fit around the dog waiting patiently in anticipation for their well-deserved treats.

All together, Paddy starred in 12 Christmas cards before he passed away. Our family had grown by this time, with the addition of twin boys and later their younger brother, who had also begun to feature in some earlier cards. We all really missed having a pet around, so after a few visits to the dog shelter, we soon adopted another terrier mix. This dog had a very gentle nature, and we named her Raggle.

After a time, I started to photograph Raggle in the studio, and she soon became my new muse. It was quite a shock to see Raggle with her first haircut, so I took a photograph making notes on the lighting and camera set up. Then I created the exact same shot six months later. That turned out to be the first Raggle Christmas card, and the rest, as they say, is history.

SEASON'S GREETINGS

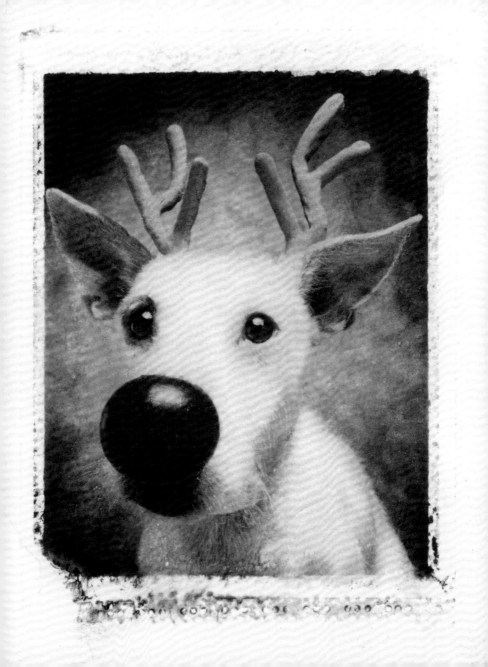

Choirboy

On the twelfth day of Christmas
My true love sent to me:
Twelve Drummers Drumming
Eleven Pipers Piping
Ten Lords a-Leaping
Nine Ladies Dancing
Eight Maids a-Milking
Seven Swans a-Swimming
Six Geese a-Laying
Five Golden Rings
Four Calling Birds
Three French Hens
Two Turtle Doves
and a Partridge in a Pear Tree

—"THE TWELVE DAYS OF CHRISTMAS"

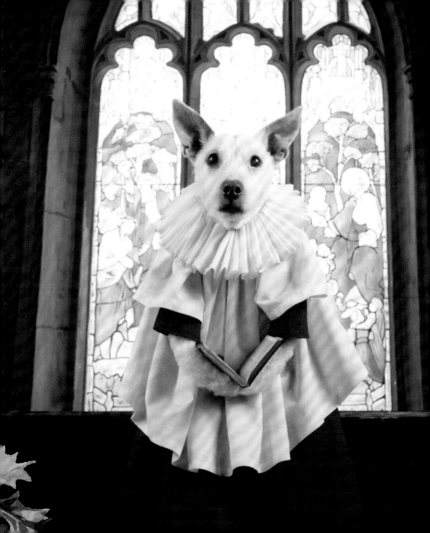

Heavenly Cherubs

Hark the herald angels sing
"Glory to the newborn King!
Peace on earth and mercy mild
God and sinners reconciled"
Joyful, all ye nations rise
Join the triumph of the skies
With the angelic host proclaim:
"Christ is born in Bethlehem"
Hark! The herald angels sing
"Glory to the newborn King!"

—"HARK THE HERALD ANGELS SING"

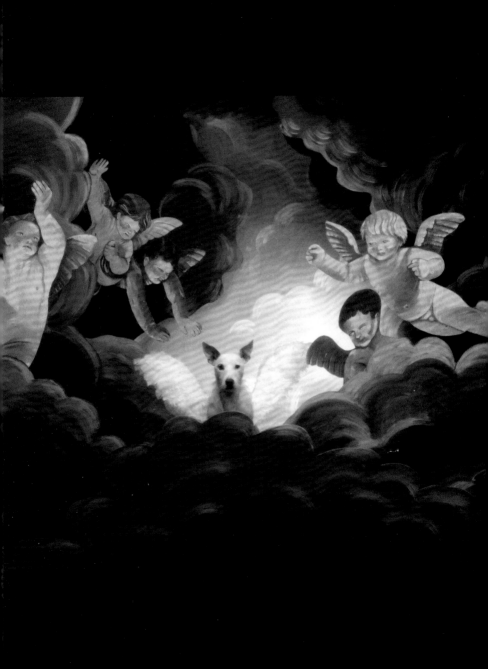

Bouncers

Here we come a-caroling, Among the leaves so green;
Here we come a-wand'ring, So fair to be seen.
Love and joy come to you, And a Merry Christmas too; So we wish you
we wish you A Happy New Year, And we wish you a Happy New Year!

—"HERE WE COME A-CAROLING"

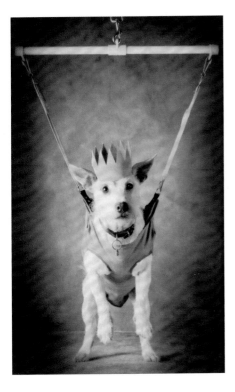

Tree Topper

O Christmas tree, O Christmas tree,
Thy candles shine out brightly!
Each bough doth hold its tiny light,
That makes each toy to sparkle bright.
O Christmas tree, O Christmas tree,
Thy candles shine out brightly!

—"O TANNENBAUM"

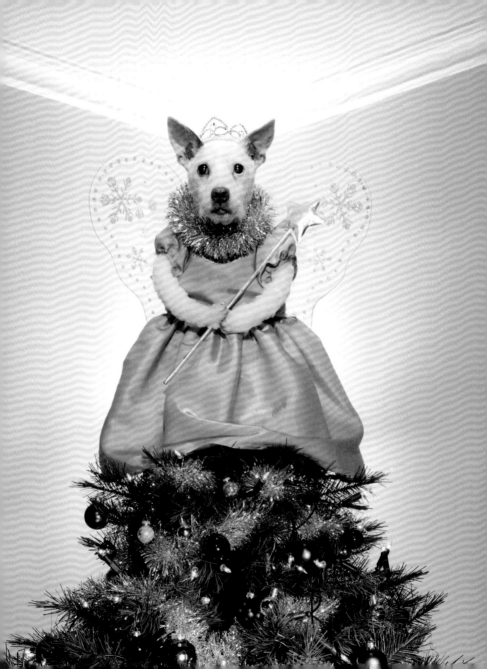

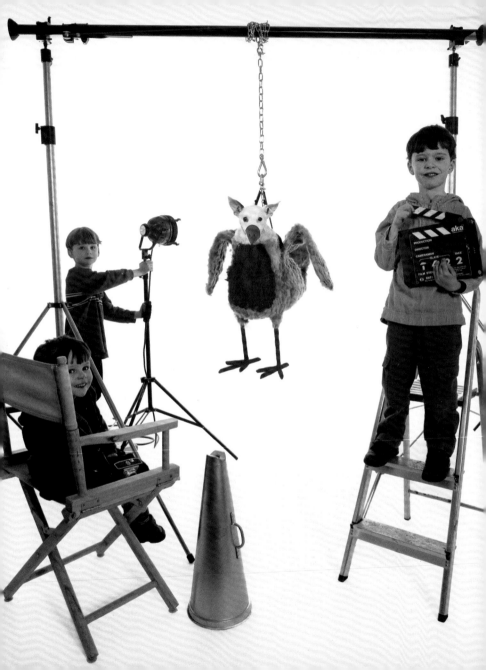

Lights, Camera, Paddy

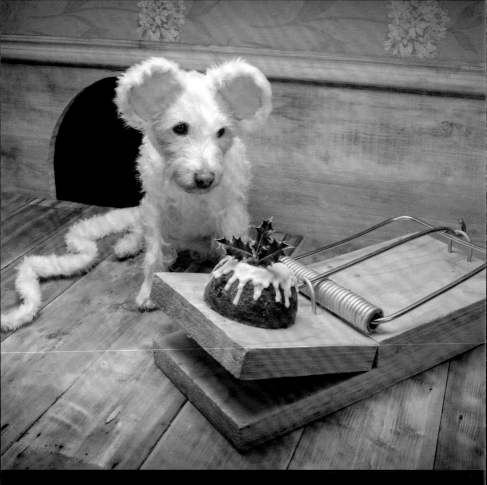

Snappy Christmas

'Twas the night before Christmas, when all through the house
Not a creature was stirring, not even a mouse;
The stockings were hung by the chimney with care,
In hopes that St. Nicholas soon would be there;
The children were nestled all snug in their beds,
While visions of sugar plums danced in their heads;

—"A VISIT FROM SAINT NICHOLAS"

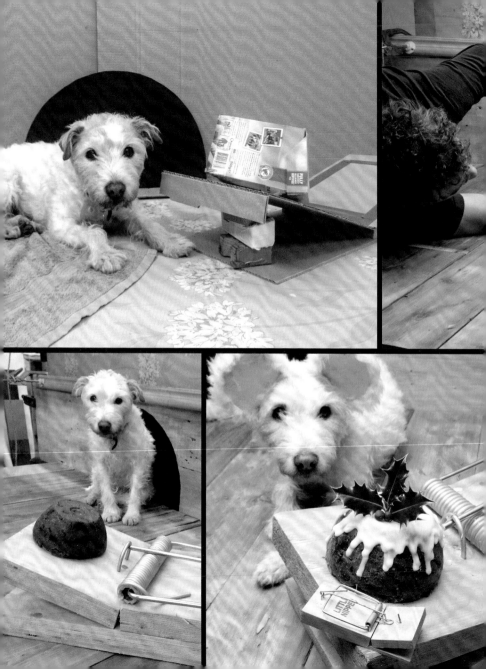

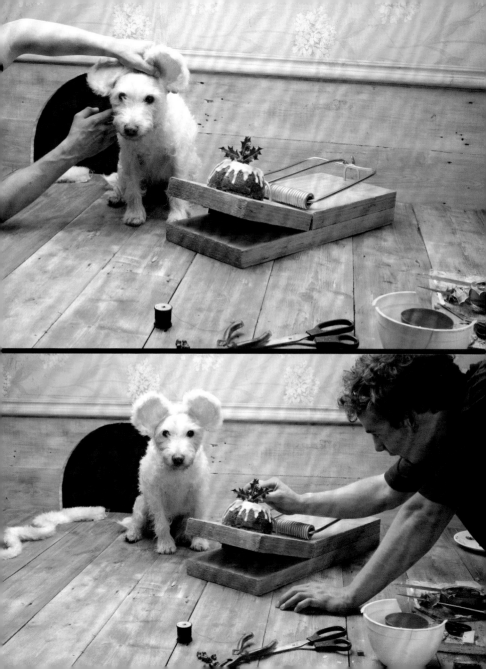

Bark Humbug

Once upon a time—of all the good days in the year,
on Christmas Eve—old Scrooge sat busy in his
counting-house. The door was open that he might
keep his eye upon his clerk. Scrooge had a very small fire,
but the clerk's fire was so very much smaller that it
looked like one coal. But he couldn't replenish it,
for Scrooge kept the coal-box in his own room;
and so surely as the clerk came in with the shovel,
the master predicted that it would be necessary for them
to part. Wherefore the clerk put on his
white comforter, and tried to warm himself at the candle;
in which effort, not being a man of a strong imagination,
he failed. "A merry Christmas, uncle! God save you!"
cried a cheerful voice.
It was the voice of Scrooge's nephew,
who came upon him so quickly that this was the
first intimation he had of his approach.
"Bah!" said Scrooge, "Humbug!"

—A CHRISTMAS CAROL

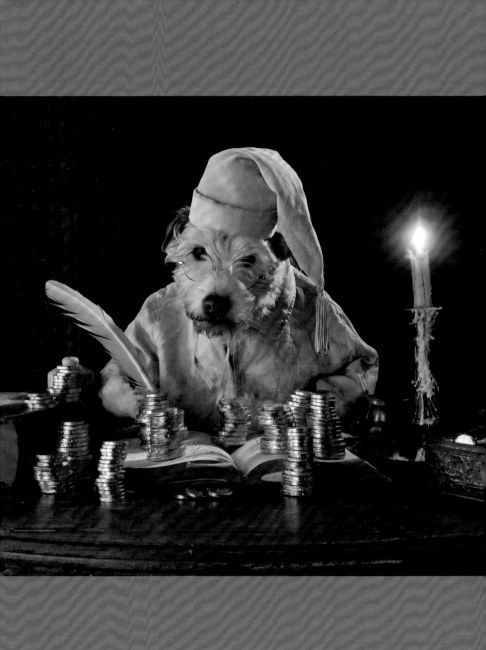

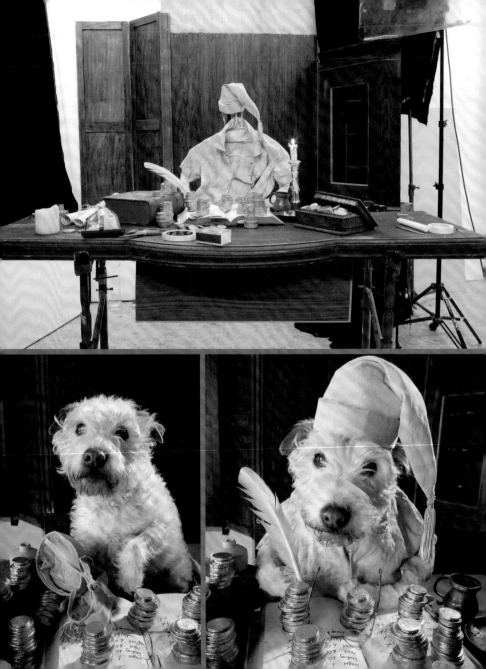

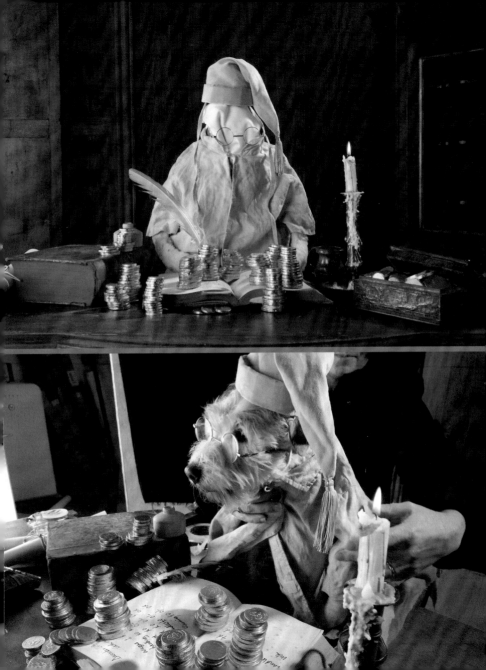

Santa Rescue

Up on the housetop reindeer pause, Out jumps Good Old Santa Claus
Down through the chimney with lots of toys
All for the little good girls and boys

Ho, ho ho! Who wouldn't go? Ho, ho ho! Who wouldn't go?
Up on the housetop, click, click, click
Down through the chimney with good Saint Nick

First comes the stocking of little Nell, Oh, dear Santa fill it well
Give her a dolly that laughs and cries
One that will open and shut its eyes

Ho, ho, ho! Who wouldn't go? Oh, ho, ho! Who wouldn't go?
Up on the housetop, click, click, click
Down through the chimney with good Saint Nick

Next comes the stocking of little Will, Oh, just see what a glorious fill
Here is a hammer and lots of tacks
A whistle and a ball and a whip that cracks

Ho, ho ho! Who wouldn't go? Oh, ho, ho! Who wouldn't go?
Up on the housetop, click, click, click
Down through the chimney with good Saint Nick

—"UP ON THE HOUSETOP"

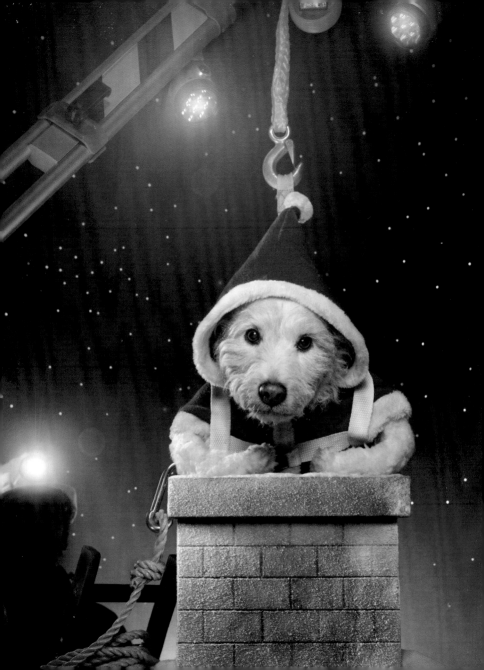

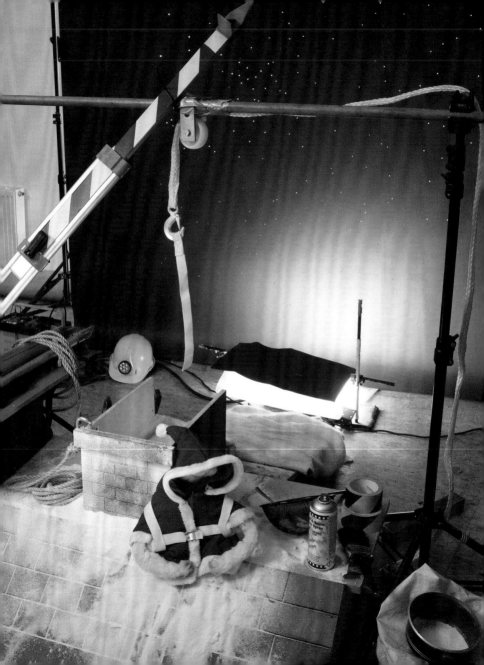

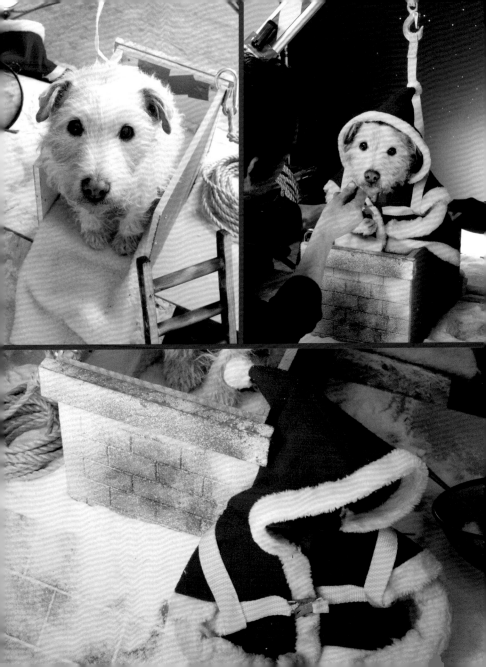

Christmas Getaway

When, what to my wondering eyes should appear,
But a miniature sleigh, and eight tiny reindeer,
With a little old driver, so lively and quick,
I knew in a moment it must be St. Nick.
More rapid than eagles his coursers they came,
And he whistled, and shouted, and called them by name:
"Now! Dasher, now! Dancer, now! Prancer and Vixen,
On! Comet, on! Cupid, on! Donder and Blitzen;
To the top of the porch! To the top of the wall!
Now dash away! Dash away! Dash away all!"
As dry leaves that before the wild hurricane fly,
When they meet with an obstacle, mount to the sky;
So up to the house-top the coursers they flew,
With the sleigh full of toys, and St. Nicholas too.

—"A VISIT FROM SAINT NICHOLAS"

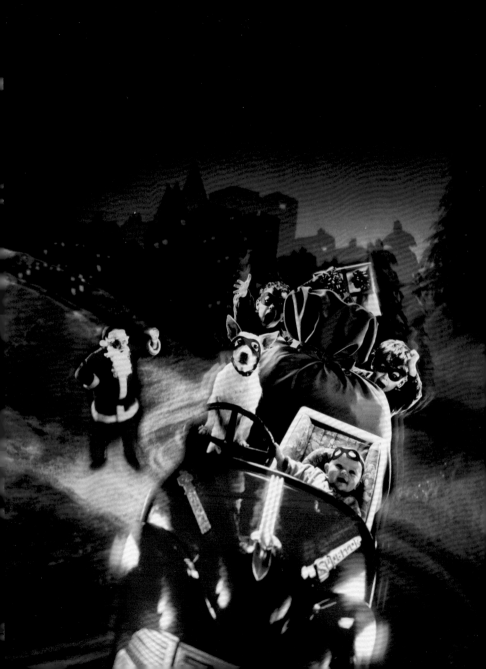

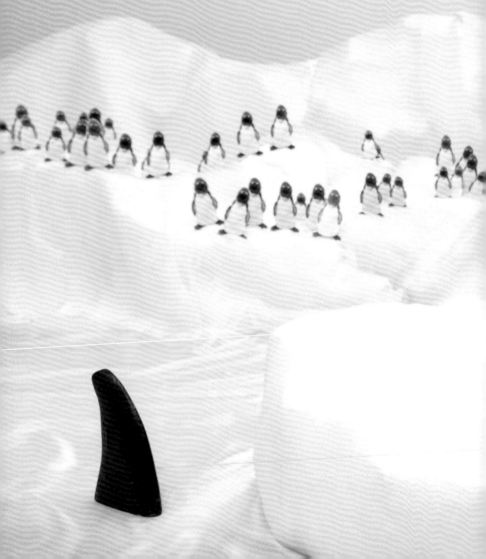

Penguin in Peril

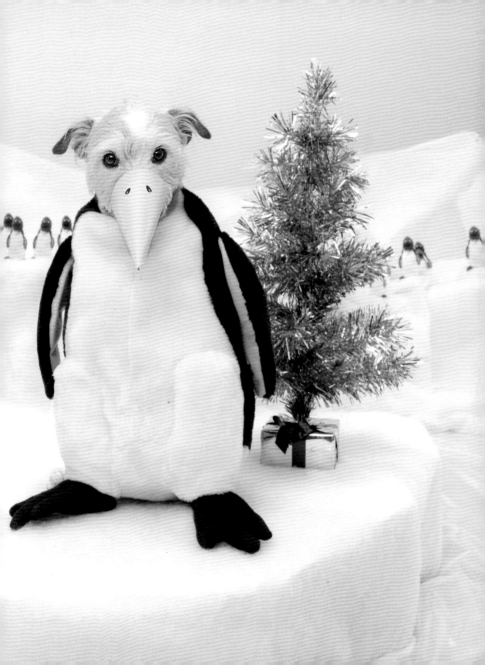

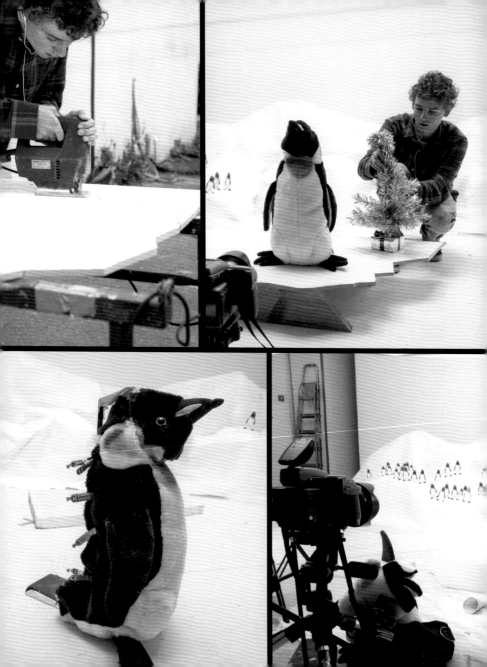

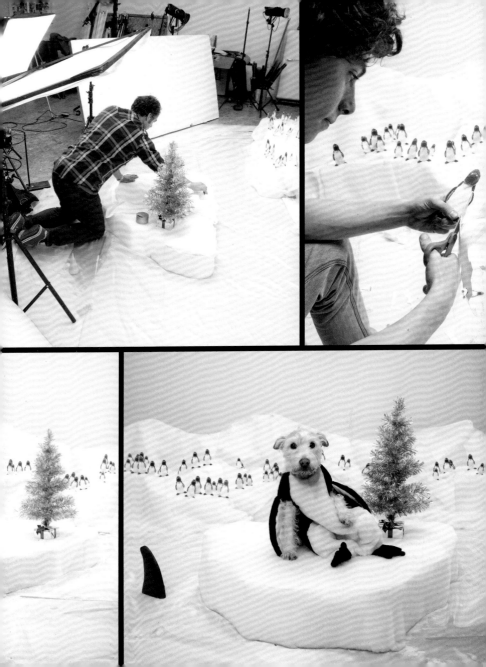

Follow Yonder Star

O little town of Bethlehem,
How still we see thee lie!
Above your deep and dreamless sleep,
The silent stars go by.
Yet in thy dark streets shineth
The everlasting Light,
The hopes and fears of all the years,
Are met in thee tonight.

—"OH LITTLE TOWN OF BETHLEHEM"

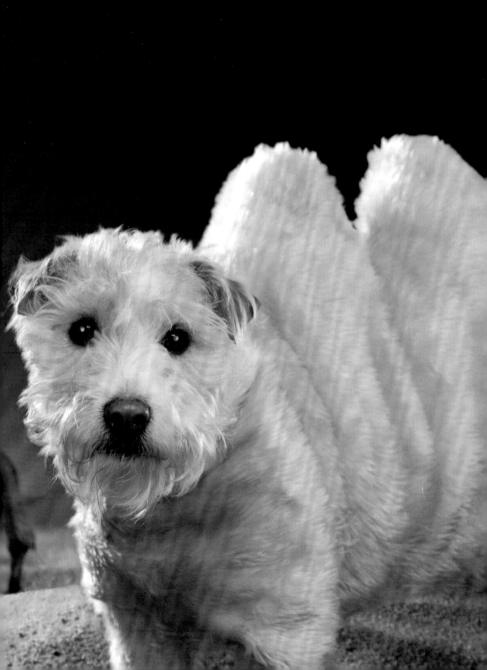

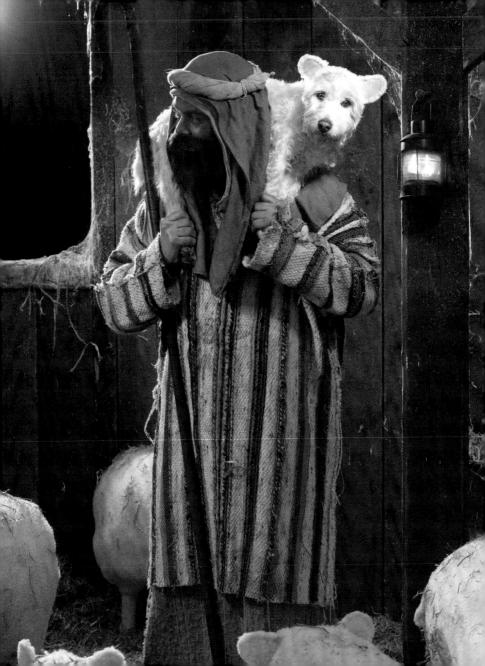

While Shepherds Watched

The First Noel, the angel did say
Was to certain poor shepherds
In fields as they lay;
In fields as they lay, keeping their sheep,
On a cold winter's night that was so deep.

–"THE FIRST NOEL"

MERRY CHRISTMAS

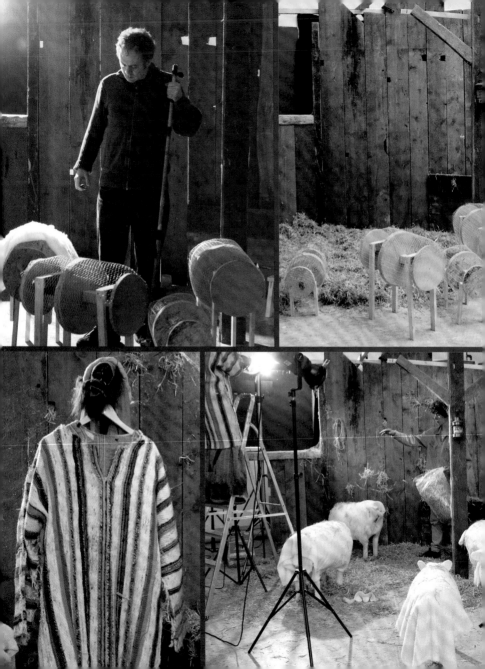

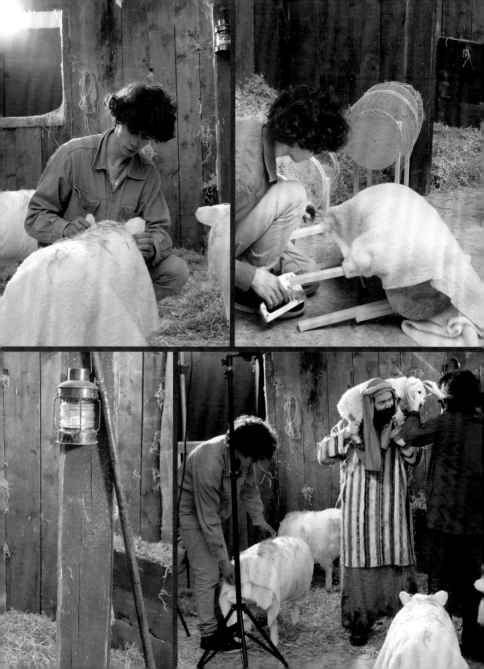

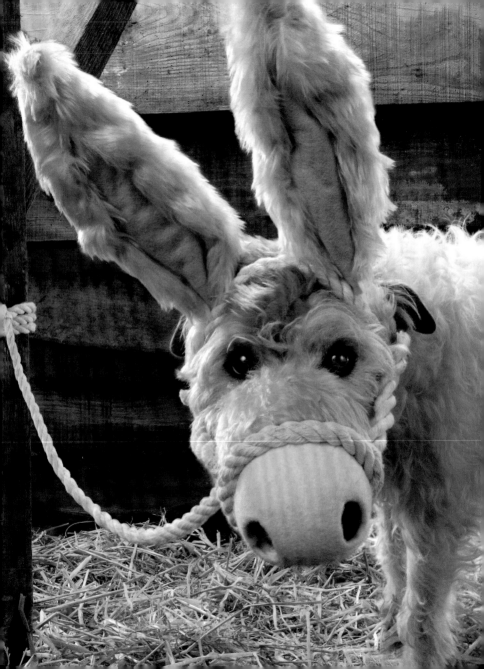

Dogkey

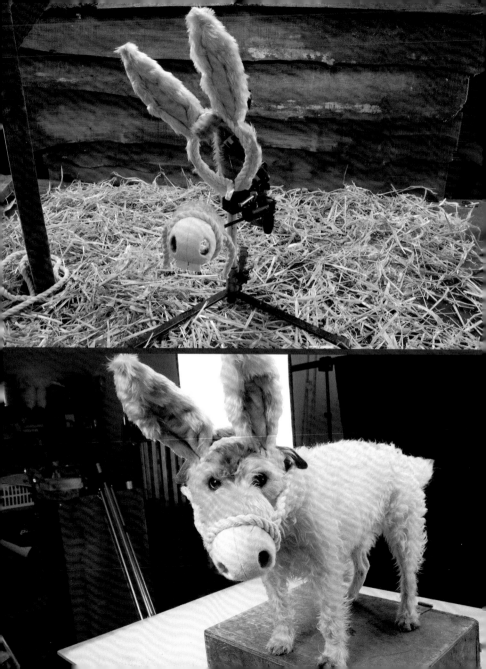

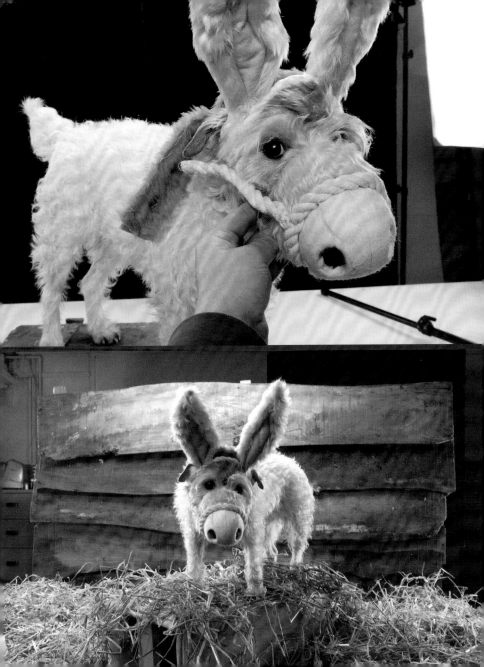

Away in a Manger

We three kings of Orient are Bearing gifts we traverse afar.
Field and fountain, moor and mountain, Following yonder star.

O star of wonder, star of night,
Star of royal beauty bright,
Westward leading, still proceeding,
Guide us to thy perfect light.

Born a king on Bethlehem's plain, Gold I bring to crown Him again,
King forever, ceasing never, Over us all to reign.

O star of wonder, star of night,
Star of royal beauty bright,
Westward leading, still proceeding,
Guide us to thy perfect light.

—"WE THREE KINGS"

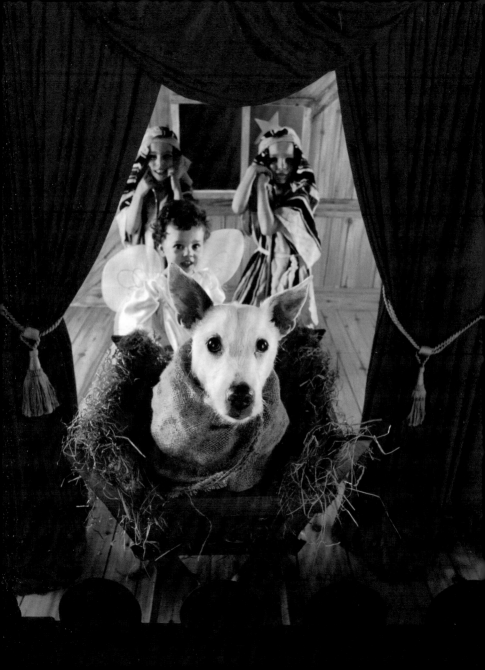

Cocomutt Shy

Toyland, toyland, Little girl and boy land
While you dwell within it, You are ever happy there

Childhood's joy land, Mystic merry toyland
Once you pass its borders, You can ne'er return again

When you've grown up, my dears
And are as old as I
You'll laugh and ponder on the years
That roll so swiftly by, my dears
That roll so swiftly by

Childhood's joy land, Mystic merry toyland
Once you pass its borders, You can ne'er return again

—"TOYLAND"

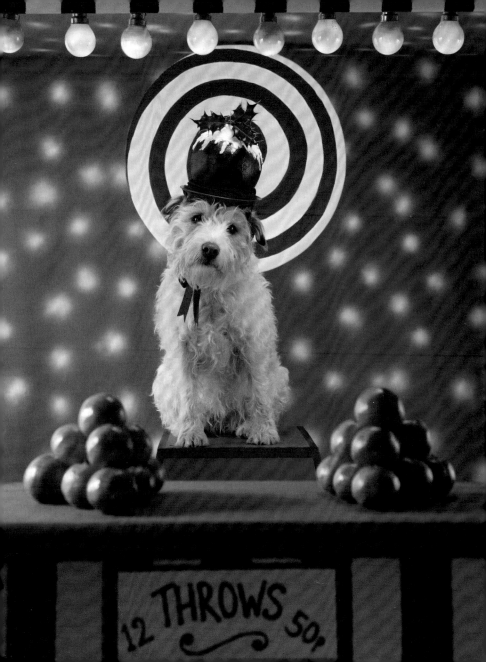

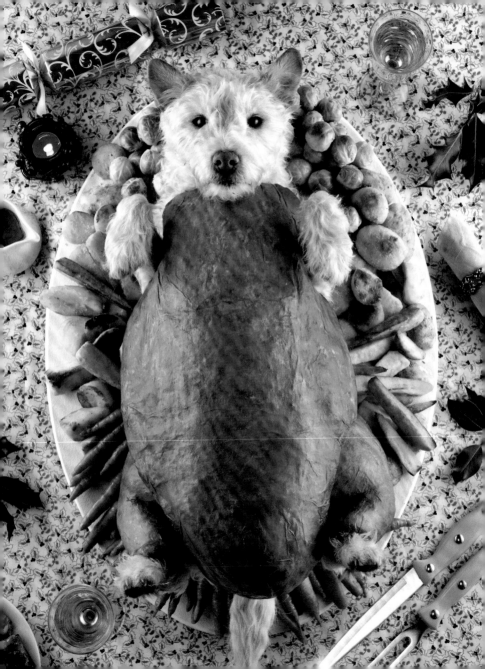

Turkey Dog Roast

Deck the halls with boughs of holly,
Fa la la la la, la la la la.
Tis' the season to be jolly, Fa la la la la, la la la la.
Don we now our gay apparel, Fa la la la la, la la la la.
Troll the ancient Christmas Carol,
Fa la la, la la la, la la la.
See the blazing Yule before us, Fa la la la la, la la la la.
Strike the harp and join the chorus,
Fa la la la la, la la la la.
Follow me in merry Christmas, Fa la la la la, la la la la.
While I tell of Yuletide treasure, Fa la la la la, la la la la.
Fast away the old year passes, Fa la la la la, la la la la.
Hail the new, ye lads and lasses,
Fa la la la la, la la la la.
Sing we joyous, all together, Fa la la la la, la la la la.
Heedless of the wind and weather,
Fa la la la la, la la la la la la la la

—"DECK THE HALLS"

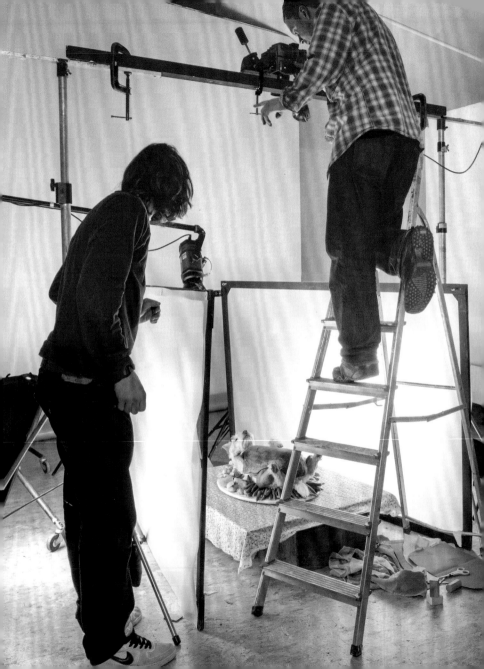

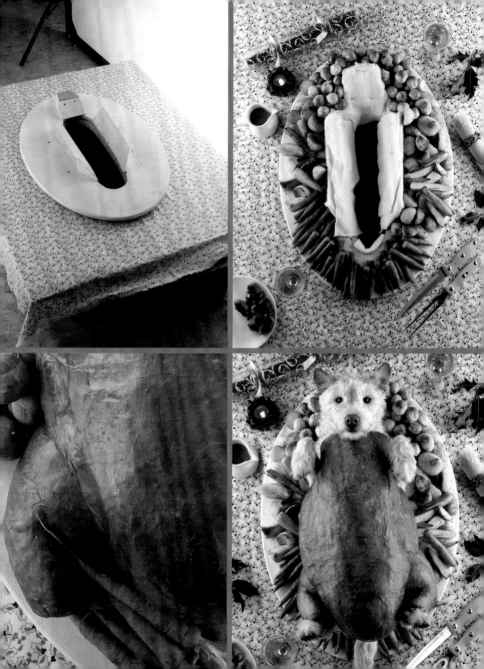

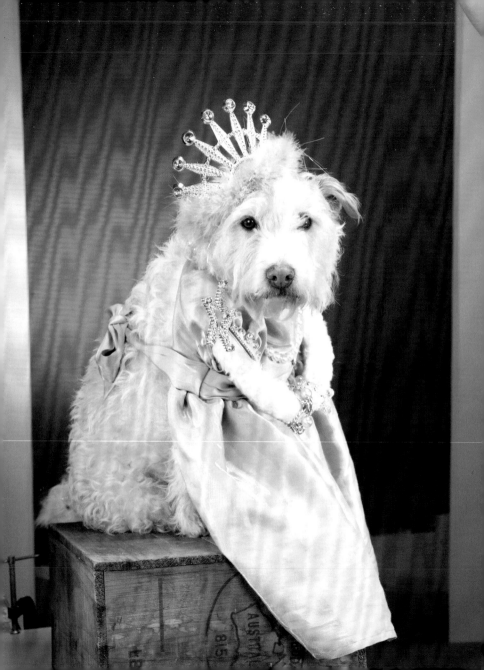

First-Class Pooch

Season's Greetings USA 20c

1ST

nta Claus

ta Claus Village

16930 Artic Circle

orth Pole —

Robin

ROBIN, Robin, you are poor,
Robin-redbreast, at my door!
Hungry creature, haste and come,
Here's a little dainty crumb:
In the sleet, and in the snow,
Friends have sent it, don't you know?
Friends all round, from every part,
Readers all of Hand And Heart
Boys and girls, throughout the land,
From the "Heart," and in the " Hand,"
For the boys in London streets,
And for girls with shoeless feet;
Of the plenty we possess,
We give some to those with less;
Yes, a Robin-feast we give,
That the poor may eat and live;
And our Christmas love to share,
Send "Round-Robin" everywhere!

—"THE ROUND-ROBIN"

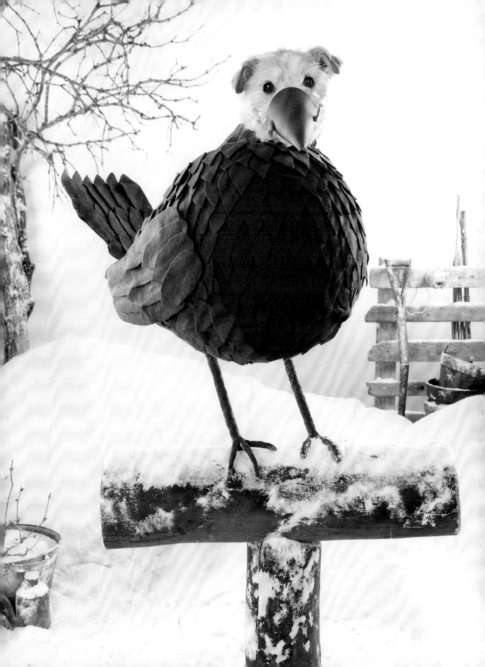

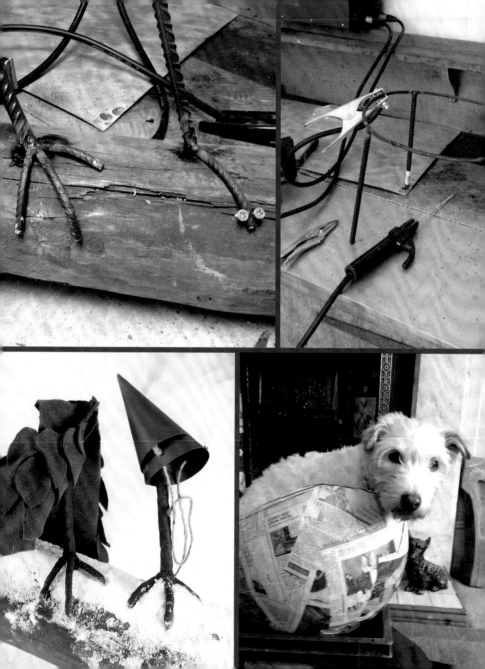

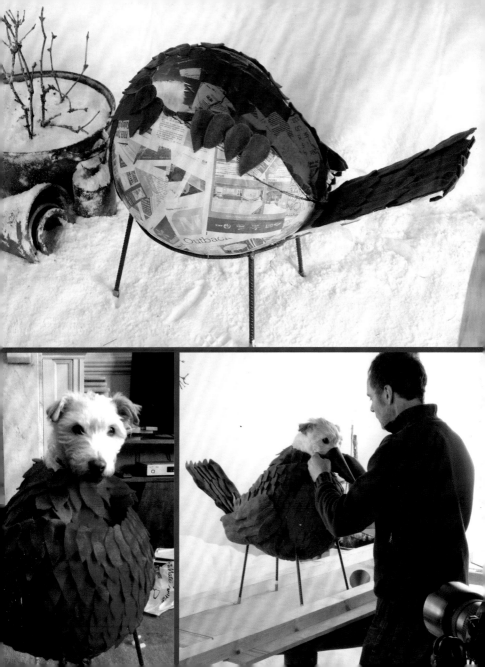

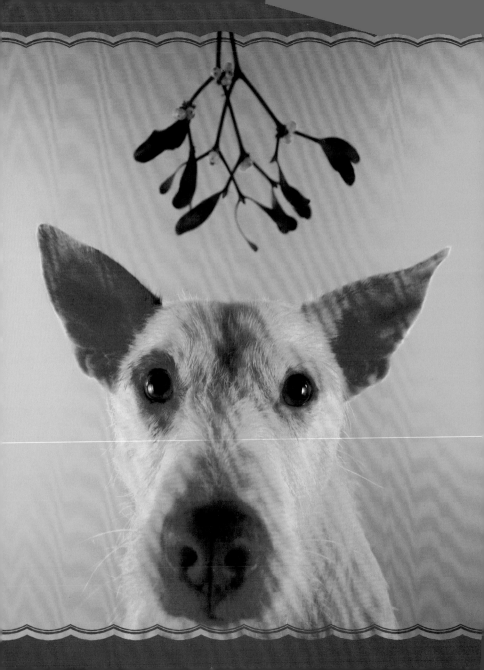

Pig Dog
Under the Mistletoe

IS merry 'neath the mistletoe, When holly-berries glisten bright;
When Christmas fires gleam and glow
When wintry winds so wildly blow, And all the meadows round are white—
'Tis merry 'neath the mistletoe!

How happy then are Fan and Flow With eyes a-sparkle with delight!
When Christmas fires gleam and glow,
When dainty dimples come and go, And maidens shrink with feignéd
fright—
Tis merry 'neath the mistletoe

A privilege 'tis then, you know, To exercise time-honoured rite;
When Christmas fires gleam and glow
When loving lips may pout, although, With other lips they oft unite—
'Tis merry 'neath the mistletoe!

When rosy lips, like Cupid's bow, Assault provokingly invite,
When Christmas fires gleam and glow,
When slowly falls the sullen snow, And dull is drear December night—
'Tis merry 'neath the mistletoe!

—"A CHRISTMAS CAROL"

Pesky Kids

Snowball here, Snowball there,
Snowball, snowball, everywhere;
Storm the fort and fight the foe,
Fast and fierce the snowballs go.

—"THE CHRISTMAS BOX"

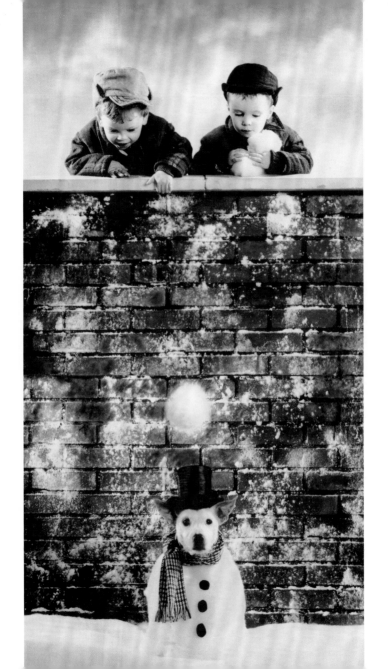

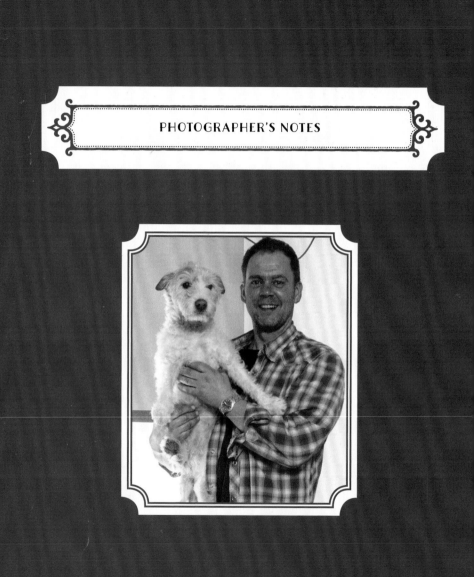

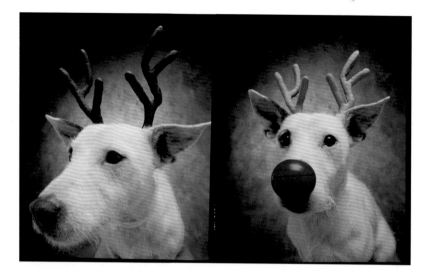

1990: RUDOLPH

Twisted wire coat hangers coated in expanding foam and a bright, shiny clown nose were all it that it took to transform Paddy into Santa's lead reindeer. To give the image a more antique, illustrative feel, I used a Polaroid transfer technique for the final image. It meant soaking a 5" × 4" color Polaroid in a shallow tray of water; then, at just the right time, when the emulsion layer could be floated off its backing, this fragile layer was then gently transferred and manipulated onto watercolor paper. The colors on the print—and some inevitably damaged areas—were restored and intensified with pastels.

1991: HEAVENLY CHERUBS

For this one, I was influenced by the classic 1663 paintings *Annunciation to the Shepherds* by Abraham Hondius and the cherubs from Guido Reni circa 1640. I set about re-creating the iconic image of the angels appearing to the shepherds with Paddy featured as the central cherub. I photographed the cherubs on 35mm film and used a projector to enlarge and trace their shapes onto hardboard sheets to the required scale. Then I cut out the shapes of the cherubs and swirly clouds. A scenic artist friend painted them with rich golden tones. After making and fitting some angel wings, Paddy sat in the center, propped up on a camera case just out of sight, quite oblivious to the dramatic scene unfolding around him.

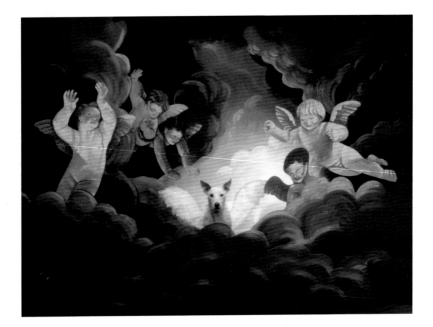

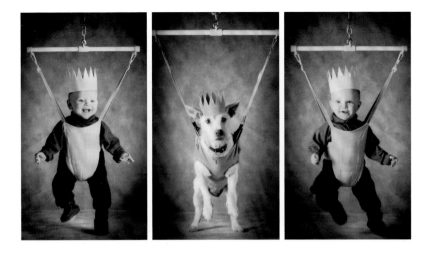

1993: BOUNCERS

Twins Joseph and Callum arrived in spring 1993. By winter, it was such a joy to see them growing well and enjoying their time in the bouncers. It was also inspiration time for a Christmas card. Would I be able to think of a way to make Paddy the third model? I made three hats—two small and one miniature—and an odd four-legged sling. Photographed separately, the boys bounced around enthusiastically. Paddy was comfortable but remained stationary in his bouncer, and for a brief few seconds we gently raised the sling, just enough to lift his front paws off the ground. For a timeless feel, I sepia-toned and hand-colored a darkroom print.

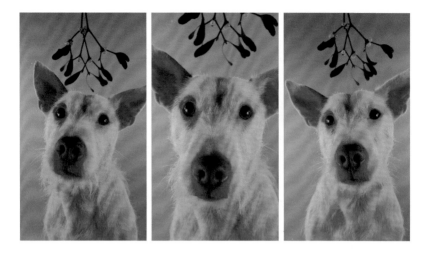

1994: PIGDOG

Shocking pink and contrasting fluorescent green gels were fitted to the lights. I used a very unflattering, wide-angle lens, close up with treats that I could circle around the lens hood for eye-line positions. Paddy appears to wait patiently under the mistletoe—who could resist a kiss from this handsome fellow?

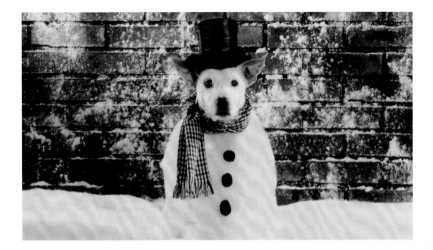

1995: PESKY KIDS

This idea was based on Dennis the Menace and other mischievous characters from the Beano comics. Throughout the year, I would often witness our lively sons behaving in a similarly cheeky way. I set about creating a scene wherein Paddy would be the unwitting victim of their snowy capers. Quilt stuffing was perfect when wrapped around Paddy, and, with the addition of a mini top-hat and some card for buttons, he was nice and snug in his snowman outfit.

The wall was made from a sheet of fake bricks, where I drilled a hole and positioned a snowball. First I photographed Paddy in a quiet studio, and later, the boys dropping snowballs onto a target below. I made and toned two darkroom prints and spliced them together along the mortar line.

1996: CHRISTMAS GETAWAY

We had another addition to the crew when our son Toby was born earlier in the year. I had also acquired a vintage bumper car around this time, so I was keen to create a theme using this as a prop. This composite print was shot in various stages and put together by hand. Toby arrived at the studio fast asleep in his car seat. Into the car he went, wearing a bandit mask. We put a mask on Paddy as well, and we placed him in the driver's seat just as Toby started to wake. Paddy was concentrating on his treats when Toby reached for the wheel and gave us a big smile. Perfect!

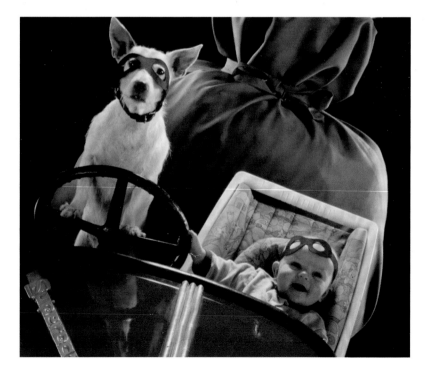

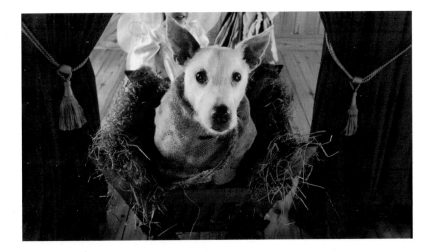

1998: AWAY IN A MANGER

With no room at the Inn, Paddy is wrapped in swaddling cloth, lying in a manger. With a few meters of swooshy red fabric, some knotty pine sheets, and footlight silhouettes cut into a length of board, we created a mini-stage. Sackcloth, hay, and 2" × 1" lumber were all it took to make a dog-size manger. With costumes fresh from their school plays, the boys played a fine role in the stable, while Paddy was the star of the show—an effortless performance at the front of the stage.

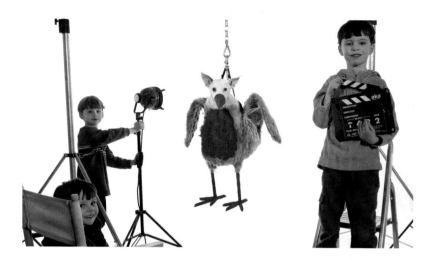

1999: LIGHTS, CAMERA, PADDY

To shoot this Christmas film scene, I created a stylized studio set with our boys posing as crewmembers. Once again working with children and animals, I had to be completely prepared, as it was likely I would only manage to shoot a couple of frames. Positions were established— Joe on the lights, Toby on the director's chair, and Callum with the clapper on the steps. For Paddy, the lead actor, we created a bespoke seat in the shape of a Christmas robin, complete with dangling legs. Here he sits, patiently suspended like a puppet, waiting for his cue to action, perhaps about to fly across a wintry scene.

2000: TREE TOPPER

I built this set to give the illusion of height, using just the top section of an artificial tree and placing a cornice detail in the background. The camera is positioned below my shooting platform, so Paddy is less than a meter off the base and sitting in a wooden crate hidden by his costume. A christening gown was sourced and it fit perfectly; fake paws were made from bent wire and fluffy fabric. Fairy wings and a few sparkly accessories turned the often-grumpy Paddy into the most unlikely tree decoration.

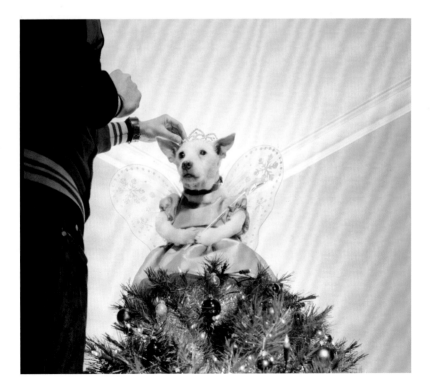

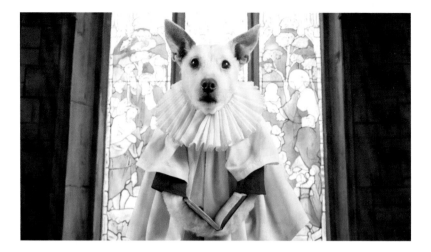

2001: CHOIRBOY

I hired in an amazing backcloth where the stained glass window could be backlit. I made the church bench from wooden boards, stained with antique pine. I had a terrier-size gown and ruff specially made. The same fake paws from Tree Topper were used again, this time holding a book of hymns. Within the reverence of the church setting, Paddy appears to give a sincere look to the camera, as if taking his performance very seriously, perhaps preparing for a solo version of "Silent Night" or "Walking in the Air." Of course, as always, he is unaware of everything we have created around him and is only concentrating on the tempting treats just off camera. Sadly, this was to be Paddy's final Christmas card before he passed away in 2002.

2005: COCOMUTT SHY

I constructed a set using references from traditional fairground side-shows, complete with working colored lights. A lightweight beach ball was painted and transformed into Christmas pudding. Next, I took a trip to the greengrocer to buy some clementines, which provided the perfect festive ammunition. Everything was carefully planned so that Raggle would only be on set with her pudding hat for a minute or two. You can see in her eyes that Raggle has complete trust that my aim is true—you may hit the pud but not the pup, Bullseye.

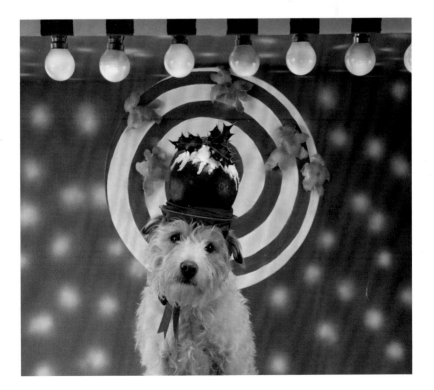

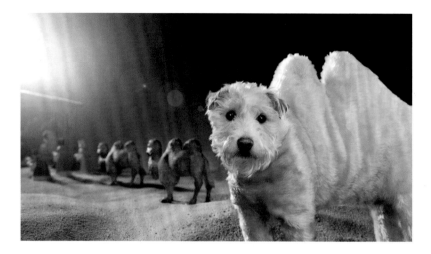

2006: FOLLOW YONDER STAR

A gentle and very well-natured dog, Raggle didn't get the hump following the star in this scene . . . in fact she got two. This was a tricky costume to make, but Raggle was happy, since it was soft, cozy, and warm. Just the item for traversing field, moor, and mountain carrying the three kings and their gifts. I had to dry out and sieve a few bags of sand and shape them into dunes, then dig out a wooden nativity set and a couple of toy camels. Behind this I painted a midnight blue background and created dramatic lighting as if from a star above the stable. Raggle was helped into her outfit, and the lovely, quizzical look she gives directly to the camera is one of total concentration, her eyes peeled directly at the tempting treats, which waved close to the camera.

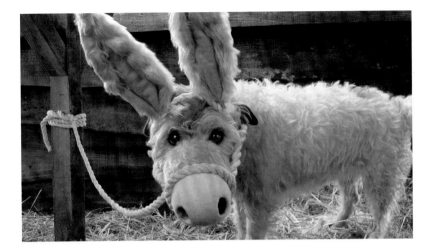

2007: LITTLE DOGKEY

Turning a little dog into a little donkey requires a trip to the craft shop, a tennis-ball nose, some modified bunny ears, and this perfect performance from Raggle. First I needed to make a stable setting, so I gathered some old planks, timber, and straw. Using fabric, wire, a small ball, felt, and cord, I was able to create donkey characteristics that could fit and be worn by a small dog. Generally, dogs are not too happy when their snouts are covered, but I practiced by placing treats inside the ball, and soon enough, Raggle would stay still for a limited time. Even just a few seconds is plenty enough to get the shot.

2008: FIRST-CLASS POOCH

In 2008, I photographed a series of pantomime characters for Royal Mail's Christmas stamps, so I thought now it should be Raggle's turn to dress up and go to the ball. I used the same christening gown and fake paws that Paddy wore on top of the tree in 2000, adding a few bits of bling and sparkle. The portrait was framed in a first-class stamp template, and Cinderella was ready to post out in time for Christmas. I have a collectable set of first-edition Christmas stamps from this series that bear a unique postmark. They were sent with a hand stamp from Bethlehem, a small village post office in Carmarthenshire, Wales, thousands of miles from its namesake in the West Bank.

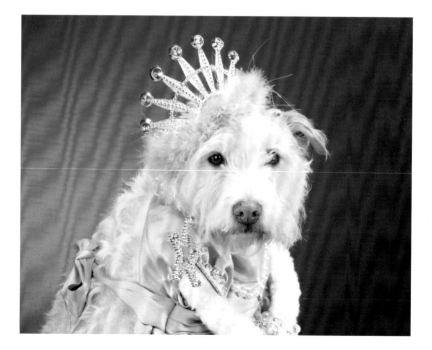

2009: DOG ROAST

Making a traditional Christmas dinner is a big culinary event. Dressing your pet up like a turkey dinner requires a little more planning and preparation. First I had to make sure Raggle was comfortable lying on her back. We practiced the pose regularly with lots of treats. When I could, I took measurements for the mold. Then I carved an oval body and drumstick legs out of dense foam, adding layers of papier-mâché and painting it a golden roast color. Then, I constructed an oval platter from plywood with a soft, comfy dog bed in the center. When it's time to take the shot, work quickly!

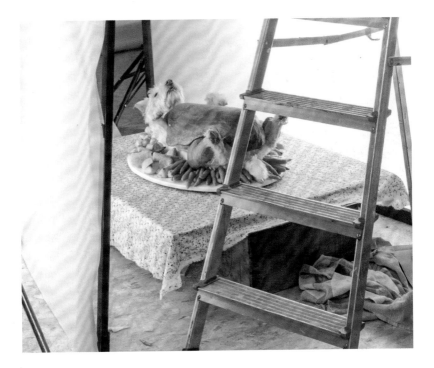

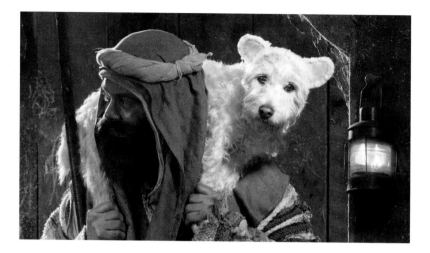

2010: WHILE SHEPHERDS WATCHED

I had the idea to re-create this classic stable and shepherd image. First, I needed to ensure that Raggle would be happy sitting wrapped around my shoulders. No problem—she was quite content to do this repeatedly. Then it was the small matter of creating a stable, a small flock of sheep, and a shepherd outfit. This set involved quite a lot of preparation and I was pleased with how it came together for the final image. I made lots of sheep-shaped ears and a special one with a chinstrap for Raggle. We added straw, cobwebs, and warm, glowing light. Then we brought in the star. With her natural fluffy white coat and a set of fake ears, Raggle played the part perfectly.

2011: PENGUIN IN PERIL

Penguins aren't the usual Christmas fodder, but this idea came from watching BBC's spectacular *Blue Planet*. Crumpled white background paper was used to form an icy mountain range and silky blue fabric for the sea. A jagged ice floe was made from a wooden sheet wrapped in white fabric. We printed and cut out lots of photos of a toy penguin and placed these in background. This same penguin was later transformed into Raggle's costume. Add a few more simple props, a fin, beak, and a Christmas tree to complete the story. Finally, a sorry look from Raggle straight to the camera, and she was quickly rescued from any danger.

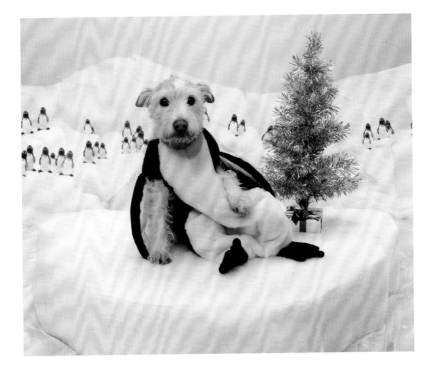

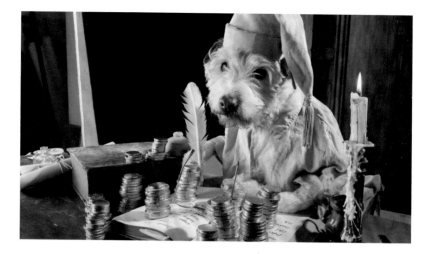

2012: BARK HUMBUG

Inspired by *A Christmas Carol*, this set-up was fun. Raggle has always been such a gentle, sweet dog, but as she gets a little older, she does show signs of grumpiness. She certainly made a convincing Ebenezer Scrooge in her nightcap, peering over her spectacles straight into the lens. We had to set up the scene with old books, quill, candleholders, and more. The blouse, stained with tea, crumpled, and fastened with velcro, Raggle wore with aplomb.

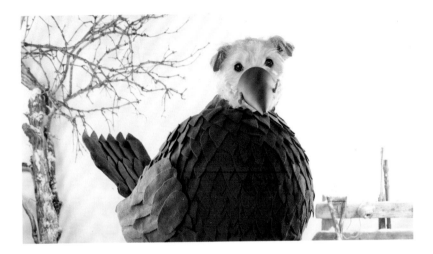

2013: LITTLE RAGGLE RED BREAST

Paddy had dangled on set dressed as a robin in 1999, and now it was Raggle's turn to recreate this cheerful traditional scene of a robin visiting a wintry garden. For the costume, a large balloon was used to create a bulbous shape in which to form the papier-mâché. After a few days building up with newspaper and wallpaper paste, the shape had set hard, ready to apply feather-shaped felt. Next, a bit of welding to make a stand and some birds legs. Then, I had to make a spade handle from thick wooden poles. After rummaging around the garden and shed for a few extra props, using crumpled paper and fake snow, I could then create the garden scene. A fake beak, and a quizzical look from Raggle, and the shot was completed in just a few minutes.

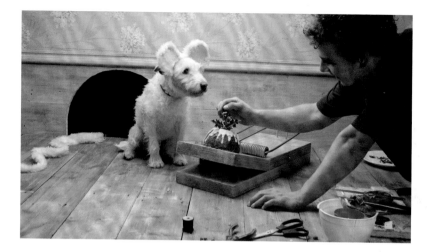

2014: SNAPPY CHRISTMAS

This idea was loosely based on the classic poem, "A Visit from St. Nicholas," commonly known as "The Night Before Christmas," by Clement Clarke Moore.

As Raggle gets older, the shots are planned in such a way that all she need do is sit in position for a few minutes. Sat by the giant mousetrap, she is very tempted—not by the Christmas pudding, but the very tasty dog treat just out of view. I began by building a Tom and Jerry–style set with floorboards, skirting, and black semicircle for a mouse hole. Then I made a visit to the fabric store to make some mouse ears, plus a tail wrapped around bent wire

From chunky wood, bent metal poles, and coiled electric flex sprayed silver, we soon had a giant mousetrap (nonworking) and for the bait, a Christmas pudding with icing sugar for brandy sauce, topped off with a sprig of holly. We achieved the quite-tempted look simply by waving tasty treats close to the pudding.

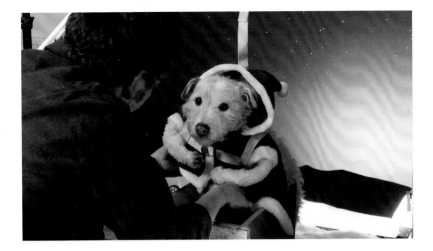

2015: SANTA RESCUE

If you're going to spend all evening going up and down chimneys, you're bound to get stuck at some point. I thought it might be amusing to imagine an emergency Santa rescue service on standby, so we created one for this shoot. First we made a wooden rooftop and chimney, painted and covered with fake snow, and then created a starry night sky behind. We built a crane with the leg of a surveyor's tripod, added hazard tape, a hook, rope, torches, and a ladder. We sourced some pet Santa outfits, then added yellow harness straps and fake paws. It was a late decision to include a figure in the shot, so I put on a helmet and got in position. Choosing the final shot was easy. One picture stood out, where Raggle appears to look slightly resigned. As with most of these photos, once completed the set is left in order to be sure no further changes are required. This set was built at low level with a ramp, so that Raggle could easily walk up to her seat in the chimney. Ever hopeful for further treats and attention, this rooftop became her new favorite spot in the studio.

Peter Thorpe is a commercial photographer based in the UK, where he has run a studio since 1986. Most of his shoots are commissioned projects for advertising and marketing campaigns, but when time allows for it, he enjoys shooting personal work too.

He has always savored the traditional process of creating theatrical sets and props in the studio, often using humor in his photographs. Thorpe lives in Bristol with his wife, Julie, their three sons, and their rescue terrier, Raggle.